Pre-Raphaelites

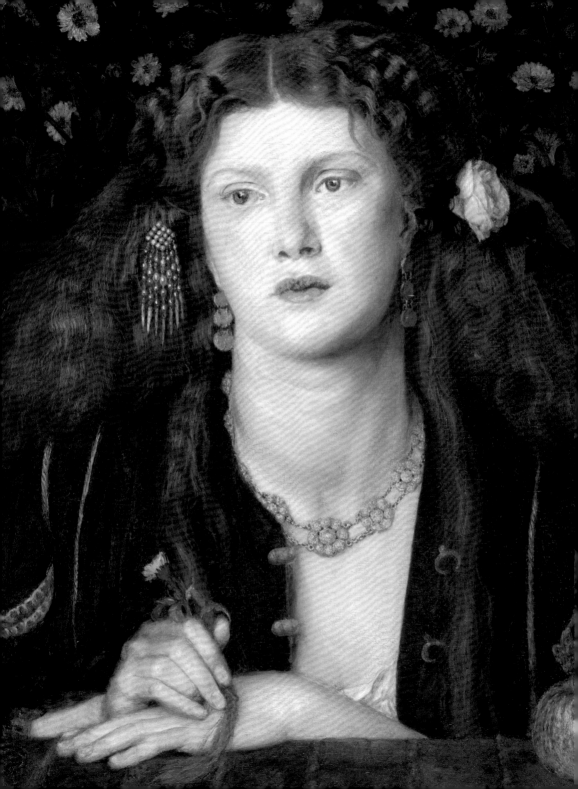

Pre-Raphaelites

Jason Rosenfeld

Tate Introductions
Tate Publishing

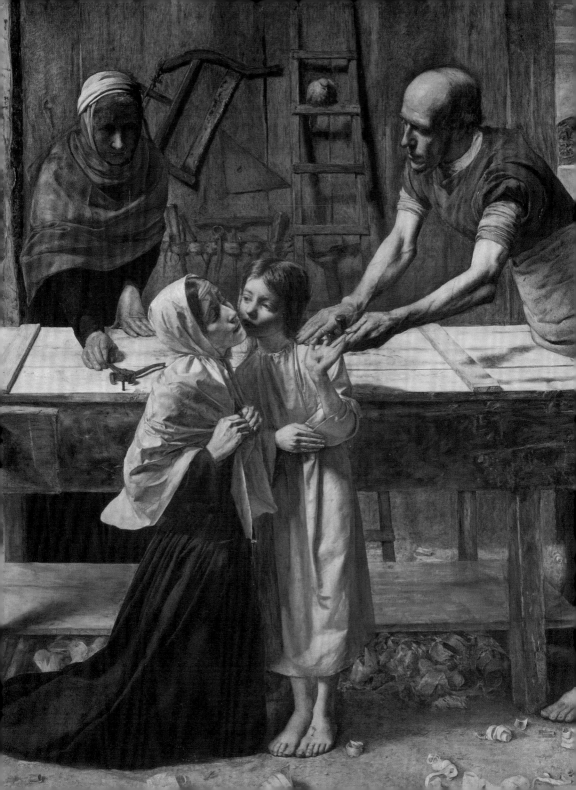

The Pre-Raphaelite Brotherhood (PRB) was a group of seven young male art students who first came together to present a unified challenge to British art in September 1848 at the London home of John Everett Millais (1829–96), on Gower Street north of Bedford Square. He was the star student at the school of the Royal Academy of Arts (RA), an institution still active today and the pre-eminent professional artists' society and organisation for art instruction in Britain since its founding in 1768. There, Millais met aspiring painters Dante Gabriel Rossetti (1828–82), William Holman Hunt (1827–1910), Frederic George Stephens (1828–1907), James Collinson (1825–81) and sculptor Thomas Woolner (1825–92). They were joined by William Michael Rossetti (1829–1910), Dante Gabriel's younger brother.

The name 'Pre-Raphaelite Brotherhood' implies an association linked by an interest in art dating to before the time of the 'Raphaelites', followers of the Italian Renaissance artist, Raphael (1483–1520). This interest was not limited to Italian art but also included artists of the fifteenth century from across Europe. The styles of Hans Holbein and Jan van Eyck in the north, and Fra Angelico and Taddeo Gaddi in the south, were not part of the range of instruction, nor favoured, in the halls of the RA, which was at that time located in the east wing of the great building on the north side of Trafalgar Square that now entirely houses the National Gallery. The Gallery then occupied the west wing of the structure and contained a modest number of impressive pictures that formed a convenient study collection for Academy pupils. The Pre-Raphaelites came to reject the Academy's standard course of instruction with its emphasis on classical art from ancient Greece and Rome, on the work of Raphael and Michelangelo, and then later Baroque masters such as Guido Reni and Peter Paul Rubens, and its members dismissed the teaching of Sir Joshua Reynolds, the RA's founding President. In doing so, the PRB established itself as the first avant-garde group in the history of British art, bent on introducing bold

new ideas, evincing change in art and challenging the broader culture.

Despite this oppositional stance, the members of the PRB sought to succeed professionally. They all came from the expanding middle classes: Hunt's father managed a warehouse in the City and Hunt himself had worked as an office clerk; the Rossettis' father was a professor at King's College London, and William Michael worked in the Excise Office at Somerset House; Millais's family were landowners with modest holdings on the island of Jersey, and saddlers in Southampton; Woolner's father worked in the post office, as did Collinson's, who also sold books and office supplies; and Stephens's parents managed a workhouse. They sought to exhibit in venues in London, especially the annual RA summer shows, and actively pursued patrons and relationships with dealers. Their careers evolved along with the rapid development of what would become the modern art world of today: dealers opening galleries and the arrival of challenges to the authority of the Royal Academy in the form of the Grosvenor Gallery, the New Gallery and the still active Fine Art Society; the rise of a national critical press that covered art in reviews, articles and celebrity-style gossip (W.M. Rossetti and Stephens would become part of this system); the increasing domination of the secondary market by Christie's and Sotheby's auction houses; the rise of an international art scene with the growth of world fairs, beginning with the Great Exhibition in the Crystal Palace in London in 1851; and technological advances that aided in the dissemination of art works through mechanical reproduction.

Artistically and stylistically, the Pre-Raphaelites were inspired by a range of works, from early Renaissance pictures they saw in the National Gallery by the likes of Lorenzo Monaco (fig.8) and van Eyck (fig.9), to Carlo Lasinio's line engravings after frescoes in medieval buildings in Pisa, Italy, and contemporary German prints. They looked at the tradition of medieval revivalism in the art of the Nazarenes, a group of German artists in Rome in the early decades of the century under whom older artists who were part of the PRB circle, Ford Madox Brown (1821–93; fig.4) and William Dyce (1806–64), had studied. They came of age in the first decade of Victoria's reign and saw the rise of an eclectic form of gothic as the chosen national architectural form, pre-eminently in the design of Charles Barry (1795–1860) and A.W.N. Pugin (1812–52) for the new Houses of

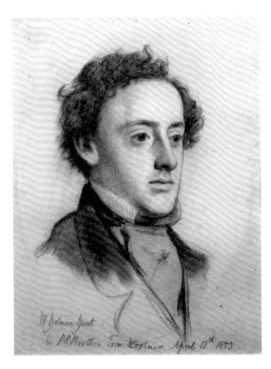

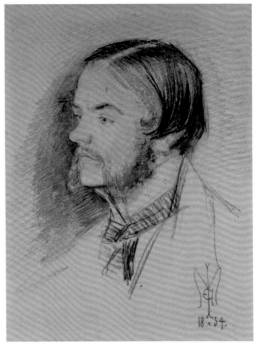

2. William Holman Hunt
John Everett Millais 1853
Pastel and coloured chalks
on paper
33.2 × 24.8
National Portrait Gallery,
London

3. John Everett Millais
William Holman Hunt 1853
Pencil with some wash
on paper
23.5 × 18.9
Ashmolean Museum,
Oxford

Parliament. Both Millais and Brown submitted work in the mid-1840s to the competitions for frescoes for this new governmental complex. Simultaneously, photography was emerging as a viable medium, able from 1839 to produce a fixed monochromatic image on paper or metal plates, and set to revolutionise two-dimensional artistic media.

The PRB further emulated the Nazarenes in making 'friendship portraits' of one another, in distinction to later avant-garde groups such as the Impressionists, Italian Futurists or the Brücke in Germany who sat for photographic or painted group portraits. The careful and precise portraits of Millais, Hunt and Brown (figs.2–4) show well-dressed, clean-cut, professional young men, consciously posing and in three-quarter view with most of their faces visible. This is the type of vivid portraiture that would be integral to their paintings, as in Millais's *Isabella* (fig.30). By contrast, Rossetti's *Self-Portrait* (fig.5) is more frontal, as the artist worked from a mirror, but his lengthy and active hair cast him as a bohemian, not yet twenty years old with full lips and a casual air. He also portrayed Elizabeth Siddall (1829–62; fig.6), who first modelled for a number of PRB-circle

artists, then became Rossetti's lover and eventual wife, and was the first significant woman artist to become a part of the PRB circle. The drawing shows her with a stylised sense of distance, but monumental and concentrating, with the heavy eyelids that feature in other images of her.

The Pre-Raphaelite approach to art was concerned with realism in many forms and a simultaneously scrupulous historicism. It is evident in the influential work of Brown, an older artist who mentored and sympathised with the upstart Pre-Raphaelites but was too practical-minded to want to associate with a radical splinter group and thus put off possible patrons. The artist trained in Belgium in the traditional style of nineteenth-century academic art, that is, taught through drawing from live models and casts of ancient, or Greek and Roman, sculpture, as were the Pre-Raphaelites. Brown was instructed in a system that prized 'history painting' – dramatic scenes from mythology, classical culture, the Bible, European history or religion – above other genres. His *Wycliffe Reading his Translation of the New Testament to John of Gaunt* (fig.26) predates the formation of the

4. Dante Gabriel Rossetti
Ford Madox Brown 1852
Pencil
17.1 × 11.4
National Portrait Gallery, London

5. Dante Gabriel Rossetti
Self-Portrait 1847
Pencil and white chalk on paper
20.7 × 16.8
National Portrait Gallery, London

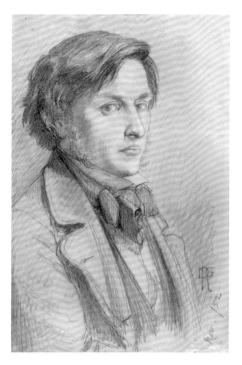

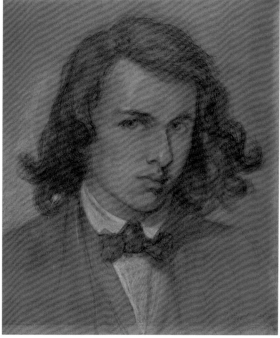

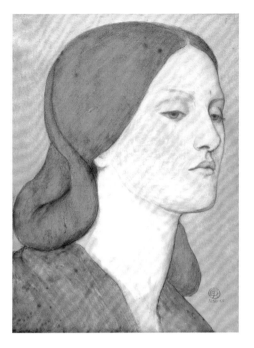

PRB. Its clarity of forms, simplified sky as a backdrop, particularity of features on each figure, and furniture and costume determined through the artist's research on the period, all coalesce to breathe life into a fairly balanced and symmetrical image of the mid-fourteenth-century scholar and religious dissident, who began his famed translation of the New Testament towards the end of his life.

Brown exhibited *Wycliffe* at the National Institution's 'Free Exhibition of Modern Art' near Hyde Park Corner in 1848, cautiously avoiding the selection committee of the Royal Academy. In the following year Rossetti submitted *The Girlhood of Mary Virgin* (fig.27) to the same venue, the first painting to appear in public under the PRB banner. Religious imagery is prevalent in Pre-Raphaelitism, but in works such as this, and Millais's subsequent *Christ in the House of His Parents* (fig.31), the artists painted scenes uncommon or novel in the history of art. Such pictures defied convention, provoked critics, entranced audiences and also appealed to new industrial and commercial patrons in the Victorian era. In Rossetti's work his sister, the poet Christina, posed for Mary, and his mother Frances, for St Anne. Rossetti signed it at left with the PRB initials and his name,

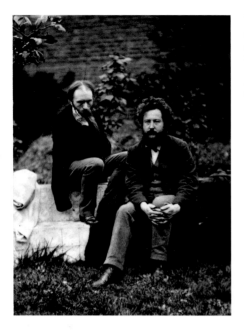

7. Frederick Hollyer
*Edward Burne-Jones
and William Morris at the
Grange when Older* 1874
Platinum print
85 x 71
Victoria and Albert
Museum, London

in lettering as careful as his tentative painting style, and inscribed an original sonnet explaining the symbolism on the frame, presaging the wedding of image and poetry in his art (fig.63).

The concern with medieval subjects in early Pre-Raphaelite drawings is reflected in the sharpness of forms, emphasis on building composition through planes parallel to the surface of the picture, sense of measured movement and intricate glances. They are marked by spiky and willowy gothic-style figures (as against the fully muscled classical tradition) and by period costume and detail, and they lack the deep shading and modelling from light to dark that was so typical of European art since the Renaissance and Baroque eras. Early Pre-Raphaelite drawings reveal the artists' most unified style, as their painting abilities varied widely. Millais's *'My Beautiful Lady'* (fig.28), dedicated and gifted to Rossetti, displays the angularity of form that the artists saw in Lasinio's engravings and gothic sculpture, as well as the clarity of natural detail (in the flowers) and the slow rhythmic bodily movement and expression typical of Pre-Raphaelite art.

At the annual Royal Academy exhibition, which opened in early May 1849, two months after the Free Exhibition closed, Hunt showed his *Rienzi* (fig.29), Millais his *Isabella* (fig.30) and Collinson his *Italian*

Image-Boys at a Roadside Alehouse (1849; private collection). *Rienzi* and *Isabella* were hung in close proximity in the privileged middle room, with the bottom of their frames on 'the line', a point 8ft (2.4m) high on the wall and just above the prime position for best viewing. Critics responded well and recognised the similarities between Hunt's and Millais's pictures, even if the meaning of 'PRB' and its members' names were not publicly revealed until the following year, when the artists were suddenly seen as threatening and revolutionary. *Rienzi* and *Isabella* depict literary treatments of subjects from early Italian history. Hunt's subject was topical: it channelled the pan-European fervour for revolutions that had broken out across the continent the year before, and the scene came from Edward Bulwer-Lytton's recently reissued novel of 1835, *Rienzi, the Last of the Roman Tribunes*, set in the fourteenth century. It shows the future liberator of Rome, appropriately modelled by the British Italian Rossetti, vowing to avenge his slain brother. It was the first Pre-Raphaelite work to be painted partially from nature out of doors, and is close to Brown's and Rossetti's work in its relatively straightforward composition and planar frontality. Millais's *Isabella* is more astounding, however; Hunt himself called it 'the most wonderful picture that any youth under twenty years of age ever painted'.[1]

Millais's subject was from a poem by the short-lived Romantic, John Keats, which was itself drafted from a story by the fourteenth-century Italian writer, Boccaccio. The clerk Lorenzo has fallen in love with Isabella, the sister of his male employers. The brothers kill him and she digs up the body and plants his head in a pot of basil in her quarters. Eventually, she dies of a broken heart. Millais used family members as models, in addition to Pre-Raphaelite members D.G. Rossetti for the man draining his glass in the background and Stephens for the intensely devoted Lorenzo on the right. He derived Isabella's outfit from a lavish book that illustrated costumes from paintings of the period. He laboured over each detail in the picture, from nutcrackers and stockings to the two dogs in the foreground. He accessed early Italian art, from before the time of the Raphaelites, by basing the forms of the lovers on two saints from the right wing of an altarpiece in the National Gallery (fig.8), by backing the figures with a predominantly golden rear wall as found in such religious panel paintings from the fifteenth century, and by disregarding traditional

one-point perspective and balanced compositions bearing a single vanishing point in favour of a wilfully skewed table, with four seated at left and eight at right. It is a deceptively complex depiction of depth that vividly brings the key protagonists to the forefront. The faces in *Isabella* reveal much about Pre-Raphaelite practice and the avid pursuit of an optically exact realism. However, as with Millais's early portraits (fig.10), they owe more to contemporary daguerreotype photographic portraits and northern painting of the fifteenth century than early Italian art, especially van Eyck's peerless *Arnolfini Portrait* (fig.9), which entered the National Gallery collection in 1842 and influenced numerous PRB works.

Rossetti withdrew from exhibiting oil paintings in public after 1850 to concentrate on watercolours (fig.34), leaving Millais and Hunt to carry the banner for the PRB. With *Christ in the House of His Parents* (fig.31) Millais took on a religious, not literary, subject and elicited criticism from one of the most formidable writers of the era, Charles Dickens. The work was a marked challenge to traditional religious imagery. By comparison, *Our Saviour Subject to his Parents at Nazareth* (fig.11) by the older artist John Rogers Herbert is an effectively academic Victorian painting that maintains softened and idealised faces and forms, and a clear compositional recession into space, as seen in the diagonals of the carpenter's shop and house on the right, and the hazy hills in the atmospheric distance. Millais's russet-haired Jesus has cut his hand on a nail and comforts his mother. Joseph leans over the door they have been making to inspect the wound. John the Baptist comes bearing water as a salve, and Anne and a Hebrew worker fill out the composition. The blood from Jesus's wound drips onto his foot, alluding to the crucifixion; other symbols of the Passion fill the wall. Inordinately curious sheep, painted from a head procured at a butcher's, crowd the rear doorway. This unsparing, unbeautiful image of common labourers seemingly playing at the Holy Family aroused the indignation of Dickens. He chided Millais for showing 'a hideous, wry-necked, blubbering, red-headed boy, in a bed-gown; who appears to have received a poke in the hand, from the stick of another boy with whom he has been playing in an adjacent gutter, and to be holding it up for the contemplation of a kneeling woman … horrible in her ugliness'.[2] Dickens objected to its realism, but also voiced the fear that such

8. Lorenzo Monaco
Adoring Saints, right main tier panel from the *San Benedetto Altarpiece*
1407–9
Egg tempera and gold leaf on wood
197.2 × 101.5
National Gallery, London

9. Jan van Eyck
The Arnolfini Portrait 1434
Oil on oak
82.2 × 60
National Gallery, London

pictures represented a resurgence of Catholic ideals in art, to match the most marked governmentally condoned reassertion of the right to practice Catholicism in England since the Reformation. But Millais was perhaps naively after a kind of perceived truth, in a style that recalled early Italian and Netherlandish art.

The writer and critic John Ruskin (1819–1900; figs.13 and 40), who had published *Modern Painters*, an ambitious defence of J.M.W. Turner (1775–1851) and landscape painting that the young members of the PRB had read avidly, wrote letters to the *Times* the following year that succinctly conveyed the group's agenda:

> These pre-Raphaelites … do not … imitate antique painting, as such … [They] intend to surrender no advantage which the knowledge or inventions of the present time can afford to their art. They intend

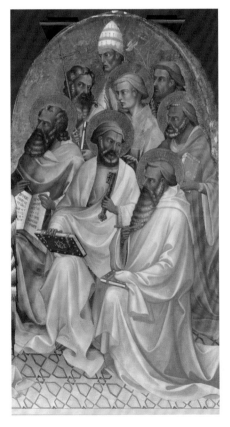
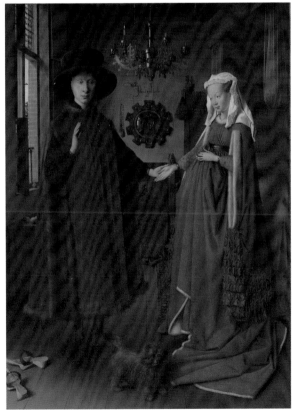

to return to early days in this one point only – that, as far as in them lies, they will draw either what they see, or what they suppose might have been the actual facts of the scene they desire to represent, irrespective of any conventional rules of picture making.[3]

Ruskin saw the PRB as simultaneously radical and part of an art-historical tradition; he recognised the movement's potential. Millais's *Mariana* (fig.32), taken from Tennyson and Shakespeare, reflects Ruskin's ideas. The sharp perspective of Mariana's room, the stained-glass Annunciation scene that serves as a transition from the interior space and worktable to autumnal nature outside, and the use of glowing colours made possible through modern, commercially produced paints bespeak Ruskin's notions of denying pictorial convention, drawing from nature, reconstructing the past and embracing technological progress through materials.

The most talented sculptor to adopt a Pre-Raphaelite style was Alexander Munro, whose intense *Paolo e Francesca* (fig.33) is from Dante Alighieri's epic poem, *Divine Comedy* (1308–21). This literary work was also a favourite of Rossetti, who would take up its themes many times over the course of his career (figs.34, 36 and 58). Paolo

10. John Everett Millais
Eliza Wyatt and her Daughter Sarah 1850
Oil on wood
35.3 × 45.7
Tate

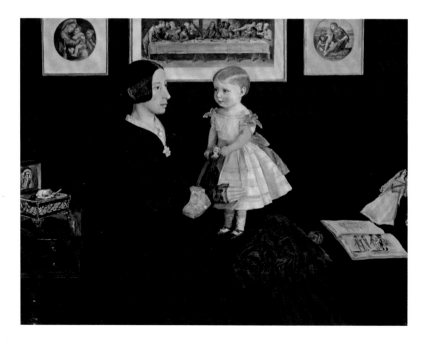

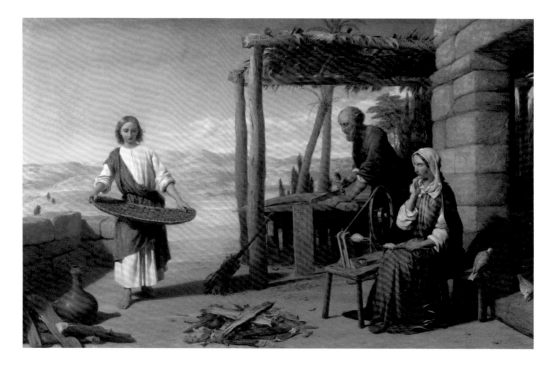

11. John Rogers Herbert
*Our Saviour Subject to his
Parents at Nazareth (The
Youth of Our Lord)* c.1847
Oil on canvas
81.3 × 129.5
Guildhall Art Gallery,
London

and Francesca fell in love while reading about Lancelot and Guinevere, whose illicit affair in King Arthur's Camelot presaged that of the Italians; Francesca was betrothed to Paolo's brother. Her seduction occurs over a book: Paolo leans over to nuzzle her neck, his right hand falling on hers, and his stockinged legs and sharp-booted feet in a twist betraying his ardour and nervousness. Munro's finely detailed and luminous marble conveys romantic heat. Yet Pre-Raphaelite sculpture, despite the similarity of its themes, costume and hairstyles to its cousin paintings, was hampered by a reliance on marble. But to have added colour or worked in a medium more agreeable to realism, such as wood, would have connoted egregious connections to ritualistic Catholic art far beyond those levelled at Millais.

William Morris (1834–96) and Edward Burne-Jones (1833–98; fig.7) were students at Exeter College, Oxford, when they were entranced by some of Rossetti's watercolours (fig.34). Giving up their prospects of pursuing religious orders, they moved to London to become artists. Morris married Jane Burden (1839–1914), daughter of an Oxford stableman, and she was the model for his only completed painting in

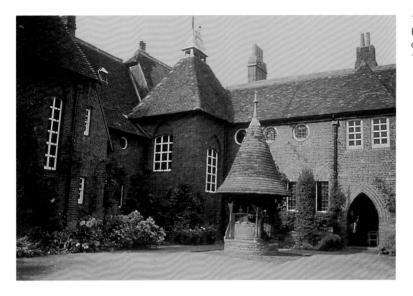

oils (fig.35), an image of Iseult, the adulterous lover of Sir Tristan. Lithe
and long-necked, with thick black hair, she would later feature in many
of Rossetti's pictures. After their marriage they moved to Red House
in Bexleyheath, Kent, designed by Philip Webb (fig.12). Members of
the PRB circle collectively decorated furniture for them, including
an extraordinary settle with painted panels. One of these was *Dantis
Amor* (fig.36), in which Rossetti revealed a predilection for the kind
of decorative patterning seen in Morris's painting, but turned to his
preferred Italian subject in a scene inspired by Dante's *Vita Nuova*
(1295) devoted to the deceased Beatrice Portinari, shown here at
lower right with Siddall's features.

Siddall herself explored similarly macabre imagery in her opulent
medievalising watercolours. *Clerk Saunders* (fig.37) is based on a
seventeenth-century ballad in which the eponymous man appears
as a ghost to his lover, whose brother has killed him. Delicate in
coloration, it is marked by Siddall's interest in sylphlike women and
spindly men, moments of quiet interaction, and emotional complexity
on the faces of her female subjects. This was also a theme in Millais's
work. In his *The Order of Release, 1746* (fig.38) a Scottish woman,
modelled by Ruskin's wife Effie who would later marry Millais, has
come with her child and family dog to an English jail to free her
husband, wounded in the Battle of Culloden. Love and passion

and family obligation preside in many Pre-Raphaelite works, but in a picture such as Henry Wallis's *Chatterton* (fig.39) the medieval meets the early modern, as the mid-eighteenth-century English poet, forger of medieval verse, lies dead in his garret of an overdose of arsenic. The precision of the forms, the vivid hues of his hair and trousers, and the senselessness of an early death communicate much about Pre-Raphaelite aims and the applicability of their style to many forms of history paintings.

Pre-Raphaelite responses to nature constitute one of the most dramatically original aspects of the movement in terms of both artistic theory and painterly style, abjuring the panoramic and collapsing the proximate and the distant. Millais's *Ophelia* (fig.41) and Hunt's *The Hireling Shepherd* (fig.42) were begun in Surrey during the summer of 1851, with the artists working for months on the detailed backgrounds, painting them inch by inch in front of fields and streams nearly two decades before French Impressionist artists like Claude Monet (1840–1926) made painting *en plein air* (out of doors) integral to their practice. The artists returned to London with canvases fully completed but for empty sections in the centre awaiting the insertion of figures painted from models in their studios. Before taking up art, Siddall, daughter of a cutlery-maker who worked at a milliner's, sat for *Ophelia* (figs.6 and 41). Millais posed her in a bathtub on Gower Street in the hopes of depicting an authentic image of Hamlet's drowning lover. The resulting painting, with its opulent foliage painted at its peak, and helpless heroine, has become a classic of the Pre-Raphaelite approach to nature, psychology and storytelling. Hunt's *The Hireling Shepherd* eschewed drama for social criticism, while using nature to heighten visual sensation. An idle shepherd, whose sheep have been left to roam unattended through the corn and consume dangerously, cosies up to a welcoming shepherdess. The lamb on her lap eats unripe apples, she hangs precariously over a stream, and all is not well in the countryside. Hunt meant this as a commentary on a perceived religious crisis about which Ruskin had published, with pastors neglecting their Anglican flocks. But the treatment of vegetation and fauna with local colours in direct sunlight remains its most striking element.

Ruskin was a key influence on Pre-Raphaelite landscape painting, and his injunction in his book *Modern Painters* was to 'go to nature in

all singleness of heart, and walk with her laboriously and trustingly, having no other thoughts but how best to penetrate her meaning, and remembering her instruction; rejecting nothing, selecting nothing and scorning nothing.'[4] The PRB took this to heart. Ruskin was a fine artist in his own right and had a sharp eye for detail and a professional interest in geology. Millais's portrait of him (fig.40), standing on rocks in a dank gulley on the River Turk in Glenfinlas, Scotland, is stunning in its treatment of the water and the volcanic gneiss stone in the background, which Ruskin also drew (fig.13), and forms a comprehensive representation of Ruskin's ideas. But the Pre-Raphaelites did not need to travel far to find prospects worthy of study. Brown's *An English Autumn Afternoon, Hampstead – Scenery in 1853* (fig.43) is a view of the growth of London's suburbs to the north, painted, as the artist once testily responded to Ruskin's query about it, 'because it lay out of a back window'.[5] The panoramic format, the specificity of time of day and season, the location in the title and the middle-class figures in the foreground provide a democratic view of a public space – Hampstead Heath. By contrast, the Pre-Raphaelite associate John Brett (1830–1902) allowed himself to be taken under Ruskin's wing and travelled to the critic's beloved Alps to paint *Val d'Aosta* (fig.44), an attempt to render in oils Ruskin's idea of 'mountain beauty' from volume four of *Modern Painters* – not a view from a suburban flat. Difficult to please as ever, Ruskin described this remarkable attempt to render an Italian view at noon in concise detail from foreground to background 'as good as standing on that spot',[6] but also bemoaned its emotional impotence, writing: 'I never saw the mirror so held up to Nature – but it is Mirror's work, not Man's.'[7] Nevertheless, Ruskin bought the picture when he learned it had been unsold at the Academy.

The Pre-Raphaelite approach to nature was applied to the depiction of the seaside in works such as Hunt's *Our English Coasts, 1852* (fig.45) and Dyce's remarkable *Pegwell Bay, Kent – a Recollection of October 5th, 1858* (fig.46). Hunt's sheep are in peril, lingering close to the cliff's edge, in a picture that he later claimed was about the defencelessness of England against a possible French invasion. Sensibly, when exhibited in Paris at the World's Fair of 1855, he changed the title to the innocuous *Strayed Sheep*. Dyce's picture lacks ruminants and any sense of danger, but shows his own

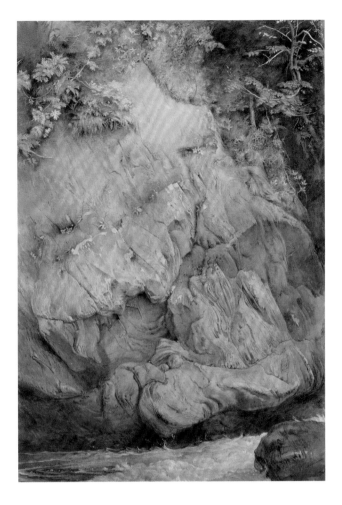

family as amateur naturalists collecting shells on the shoreline near
Ramsgate, and the date in the title signifies the appearance of Donati's
comet in the sky above. It is a celebration of both a prosaic sunset
and a more celestial majesty. The finest example of Pre-Raphaelite
sculpture that followed the naturalistic creed is *Linnaeus* by John
Lucas Tupper (c.1824–79), produced for the new Oxford University
Museum (fig.47). The Swedish eighteenth-century botanist and
taxonomist stands in an extraordinary full-length Lapland coat and
contemplates a sprig of flora, while his left fingers hold his place in a
Bible under his arm. Produced just three years before the publication
of Charles Darwin's *On the Origin of the Species*, it anticipates the

challenge of teaching science in a religious university in this one image, whose attention to detail and realism are remarkable for the period.

In addition to developing a wholly original approach to imaging nature in their art, the Pre-Raphaelites made religious painting a key genre over their entire careers. In a time of great spiritual upheaval in Britain, Millais's *Christ in the House of His Parents* (fig.31) and Hunt's grandiose historical reconstruction, *The Finding of the Saviour in the Temple* (fig.54), became the most talked-about pictures of their age. Pre-Raphaelite religious art, almost none of it made for religious institutions nor of traditional subjects, combined a realist approach to portraiture, environs and human experience with new interpretations of texts to produce works of great feeling, verisimilitude and striking visualisation. And after the first years of the PRB religious ideas became interwoven with images of modern life, as seen through the detailed depiction of relationships, personal, social and economic. More unsparing than sentimental, Pre-Raphaelite scenes of contemporary life raised questions of morality and often challenged social norms of the Victorian period, such as the condemnation of the prostitute or 'fallen woman'. Ambitious pictures, packed with telling detail, dealt with troubling social issues like emigration, illegitimacy, bereavement and poverty. Brown's great social panorama, *Work* (fig.48), with its biblical quotations on the frame and painted partly on a street in Hampstead, encapsulated in monumental fashion the moral importance of labour and the work ethic. Its treatment of the vast panoply of the social tableau under bright sunlight and accompanied by a long text prepared by the artist renders it one of the most formidable statements of artistic intent and cultural commentary in the history of art. In *The Last of England* (fig.49) Brown turned his critical brush to emigration, posing himself and his wife Emma as rootless Britons, forced by desperate economic times to seek fortune abroad. Its unsparing realism and somewhat nautical telescoping of imagery into a circular frame form one of the fiercest political and economic critiques of the age.

Hunt and Rossetti also examined contemporary life and moral ills. In *The Awakening Conscience* (fig.50) Hunt constructed a scenario of a kept woman in the rented flat of a married man; inspired by a snippet of song from her innocent youth, the woman has resolved

to change her sinful state and rises to greet nature, and freedom, seen through the open windows reflected in the mirror behind. In Rossetti's unfinished *Found* (fig.51) a man bringing a calf to a central London market in the early morning hours has come across a woman he knew in his youth. She is bedraggled and adrift, having turned to a life of prostitution, and in her despair resists his attempts to offer her assistance.

Hunt was not content with producing morally freighted pictures in London and its environs (figs.42 and 50). He had painted *The Light of the World* (fig.52), an icon of the age, which he saw as a pendant to *The Awakening Conscience*, as if the woman in that picture was responding to Christ's knock on the door, but his fervent religiosity now spurred him to want to render scenes from scripture in his Pre-Raphaelite style. To do so meant travelling to the Holy Land and imbibing the atmosphere and history of the landscape in which Christ had walked. He spent time in the desert near the Dead Sea painting *The Scapegoat* (fig.53), one of the most startling images of the century. Later in his life he participated in dramatising the lengths to which he had pursued Pre-Raphaelite realism, posing somewhat ludicrously in the costume of an explorer and colonialist, with a rifle under his arm, and wielding a loaded brush (fig.14). The most

14. William Holman Hunt Re-enacting the Painting of *The Scapegoat*, 1895 Albumen Print 17.5 × 22.5 Private Collection

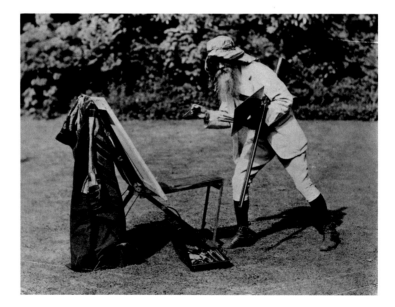

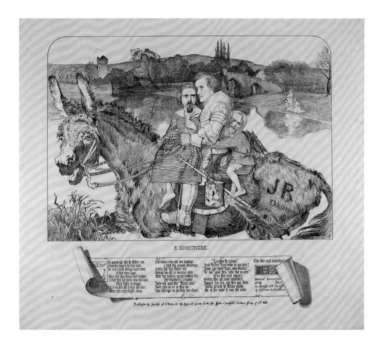

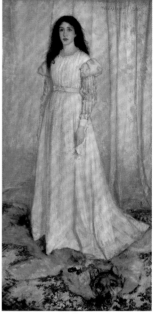

ambitious product of his sojourn in the Middle East was *The Finding of the Saviour in the Temple* (fig.54), a grandiose and large-scale re-creation of the Hebrew Temple during the time of Augustus combined with a direct and realist recitation of the garments and religious objects he associated with a kind of timeless Judaism. This picture was a sensation in London at a private exhibition (as would also happen with Brown's *Work*) and on tour in provincial cities, and was produced as a very successful print. By 1860 Pre-Raphaelitism had become a familiar and accepted style in the English art world, but the way that the artists constantly challenged themselves by taking up new themes or working in original locations allowed the movement to keep its cutting edge.

One such novel theme was the development of a modern concept of beauty. The Pre-Raphaelite Brotherhood dissolved as a functional group in 1853, although some artists and critics still perceived them as a unified entity riding the influence of Ruskin into the later years of the decade, as satirised in *A Nightmare* by Frederick Sandys (1829–1904; fig.15).[8] Yet each artist went on to develop a distinctive style and his own preferred subjects. In the early 1860s many of their works

15. Frederick Sandys
A Nightmare 1857
Zincotype proof
33.6 × 48.6
The British Museum

16. James McNeill Whistler
Symphony in White, No. 1: The White Girl 1862
Oil on canvas
214.6 × 108
National Gallery of Art, Washington

17. John Everett Millais
The Eve of St. Agnes
1862–3
Oil on canvas
117.8 × 154.3
The Royal Collection

18. Julia Margaret
Cameron
Mariana 1875
Albumen Print
35 × 45
Wilson Centre for
Photography

ceased to be preoccupied with social, moral and religious problems and instead began to appeal directly to the senses, exploring the possibilities of carefully balanced harmonies of colour and texture in place of the then jarringly radical realism of earlier years. The Pre-Raphaelites thus became pioneers of the Aesthetic Movement, whose creed of 'art for art's sake' dominated avant-garde culture of the 1860s. Rossetti increasingly assumed the leadership of an avant-garde and bohemian circle, including William and Jane Morris, Edward Burne-Jones, James McNeill Whistler (fig.16), Frederick Sandys (fig.15) and Simeon Solomon, as well as his model, mistress and collaborator in his construction of female beauty, Fanny Cornforth (c.1835–c.1906), and literary figures such as Algernon Charles Swinburne. Pre-Raphaelite paintings of this period are notable for their sensuous rendering of flesh and fabric and direct sexual appeal.

Millais set the standard in 1856 with a hypnotic and ambiguous picture, *Autumn Leaves* (fig.55), that pushed even further the early Pre-Raphaelite ideas of nature, with the scintillating Scottish sunset from the garden of his house in Perth; of narrative, with a scene absent of literary reference or narrative beyond the gathering and burning of leaves; and of society, in aiming at a universalist sentiment by including working-class girls on the right along with his two sisters-in-law in the centre. This enigmatic picture, and its associations with nostalgia and appeal to the senses, inspired a raft of suggestive art

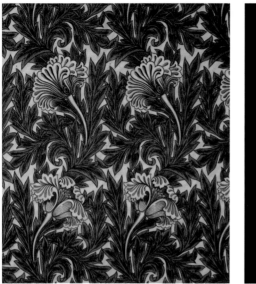

19. Morris & Co., designed
by William Morris
Detail of *Tulip* textile
Printed cotton
William Morris Gallery,
Borough of Waltham
Forest

20. Morris & Co., designed
by Edward Burne-Jones
Last Judgement 1897
Stained glass
Birmingham Cathedral
(west window)

with concepts of beauty at the forefront.

In the next year Millais again painted his wife's eldest sister Sophie (fig.56), but in a truncated format that concentrated on her face and features and established a new benchmark and format for beauty in the period. Millais painted what he saw and without the influence of past art. By contrast, two years later Rossetti's similarly composed *Bocca Baciata* (fig.57) was a statement of his own ideal of female beauty, marrying a portrait of Cornforth with the idea of woman in the works of Titian and Giorgione with long necks, full lips and cascading hair – an image of 'Pre-Raphaelite' womanhood that prevails in the popular imagination. The title refers to a line from Boccaccio – 'the mouth that is kissed' – Rossetti thus retaining poetic and past associations. In *Beata Beatrix* Rossetti leavened this soft-focus vision of female beauty with an elegiac tribute to Siddall, his recently deceased wife (fig.58). Her passing is connected with the death of Beatrice, Dante Alighieri's own obsession, signified by the figures of Love and of the poet in the middle ground, and a gilded view of Florence in the background. Millais, despite some further and remarkable forays into Aestheticist realms (fig.17), evolved into the most successful and creative portraitist in England before John Singer Sargent arrived on the scene in the late nineteenth century,

and Rossetti developed an opulent imagery that had an impact on photography (fig.18) and prefigured many concerns of turn-of-the-century Symbolist art movements.

Related to the transformation of Pre-Raphaelitism into Aestheticism was the formation in 1861 of the firm of Morris, Marshall, Faulkner and Co., spearheaded by Morris. Its products were designed by Morris, his lifelong collaborator Burne-Jones, Rossetti, Madox Brown, Jane Morris and her daughters, and others, and included wallpapers, textiles (fig.19), tapestries (fig.59), carpets, stained glass (fig.20) and furniture (fig.23). Morris emphasised the idea of collective and co-operative artistic activity in the applied arts, an important innovation in art making from the late nineteenth century to the present. Later known as Morris & Co., the firm survived until 1940. Morris and Burne-Jones later turned to social reform, and eventually Morris developed a brand of socialism in which the aesthetic played a key role, as evident in his utopian novel, *News from Nowhere* (fig.21), whose frontispiece is his country home, Kelmscott Manor in Gloucestershire, preserved and now maintained by the Society of Antiquaries (fig.22). Morris and his followers, such as Walter Crane, created an iconography for British socialism, whose forms developed from Pre-Raphaelitism.

21. William Morris
Spread from *News from Nowhere* 1890
Bound volume
21 × 15 × 3.4
Victoria and Albert
Museum, London

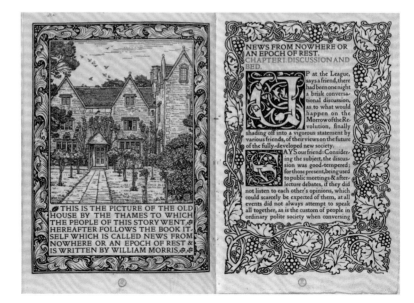

The late work of the former Pre-Raphaelites was notable for the way in which each artist explored an increasingly idiosyncratic personal vision that was opulent in scale and fabrication. After 1877 the upstart Grosvenor Gallery, a 'palace of art', provided an elegant and luxurious setting for the display of Burne-Jones's decorative large-scale paintings, many of which envisioned a quasi-medieval utopia (figs.60 and 61). Others elegantly reinvigorated traditional subject matter, such as the nude and mythological tales like that of Perseus and Andromeda (fig.62), in compositions that, with their softly rendered flesh and swirling forms, both recall works of the Italian Renaissance and look forward to the naturalistic designs of continental Art Nouveau. Rossetti's and Hunt's later works explored original literary subjects and heightened psychological states, manifesting a concern with interiority and the self that was a hallmark of Symbolist art and of late-nineteenth-century literature and psychology. In Rossetti's imposing *Astarte Syriaca* (fig.63) the 'femme fatale' archetype so popular in the late nineteenth century appears in the form of the Syrian love goddess (bearing Jane Morris's features) and, as with his earliest oil (fig.27), accompanied by an original sonnet. Hunt's *The Lady of Shallot* (fig.64), begun in 1888, both reprises an Arthurian subject from Tennyson that he had sketched forty years earlier and, in its crush of details, action and candy coloration, leaps forward to the age of computer-generated imagery. It took him nearly twenty years, over the course of which he suffered diminished eyesight. Millais continued to produce historical and religious pictures

22. Kelmscott Manor, Gloucestershire

23. May Morris, Jane Morris and Assistants William Morris's Bed with pelmet, curtains and spread 1891–1910 Society of Antiquaries, Kelmscott Manor

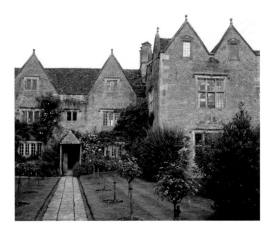

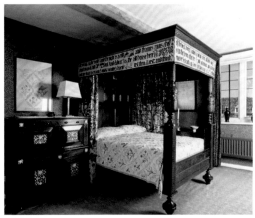

LE SURRÉALISME SPECTRAL
DE L'ÉTERNEL FÉMININ PRÉRAPHAÉLITE

par SALVADOR DALI

24. John Everett Millais
Chill October 1870
Oil on canvas
141 × 186.7
Collection: Lord Lloyd
Webber

25. Salvador Dalí
'La Surréalisme
Spectral de l'Éternel
Féminin Préraphaélite',
in *Minotaure*, no.8, 15
June 1936, p.46
Tate

later in his career, but as his portraiture practice grew along with his family (he would have eight children), and he accrued medals and honours including a baronetcy in 1885, he turned for release to landscape painting out of doors in Scotland (fig.24). He created some of the most evocative and sweeping images of nature of the period, not in the laboured detail of *Ophelia* but with a new type of realism transformed by active brushwork and a continued reliance on working in nature.

The influence of Pre-Raphaelitism has been broad, and forms a parallel stream to conventional histories of modern art that trace the rise of Paris in the mid-nineteenth century as an artistic centre and then follow the thread to New York after the Second World War. But any number of movements and styles are unimaginable without the PRB – Symbolism, Surrealism (fig.25), Art Nouveau, Art Deco, and the rejection of abstraction in modernism by figurative and Pop artists in the 1960s – demonstrating the long influence of Britain's first artistic avant-garde.

26
Ford Madox Brown
The First Translation of the Bible into English: Wycliffe Reading his Translation of the New Testament to his Protector, John of Gaunt, Duke of Lancaster, in the presence of Chaucer and

Gower, his Retainers
1847–8, reworked
1859–60
Oil on canvas
119.5 × 153.5
Bradford Art Galleries and Museums

27
Dante Gabriel Rossetti
The Girlhood of Mary Virgin
1848–9
Oil on canvas
83.2 × 65.4
Tate

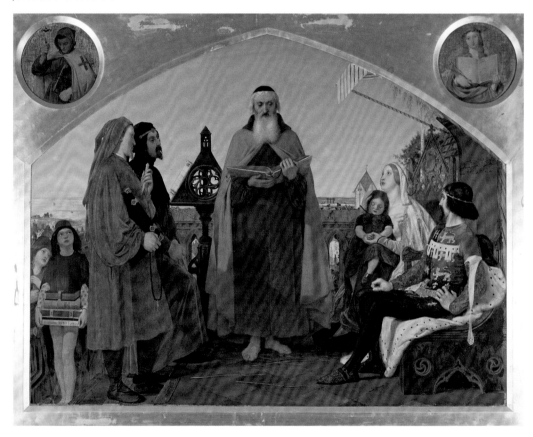

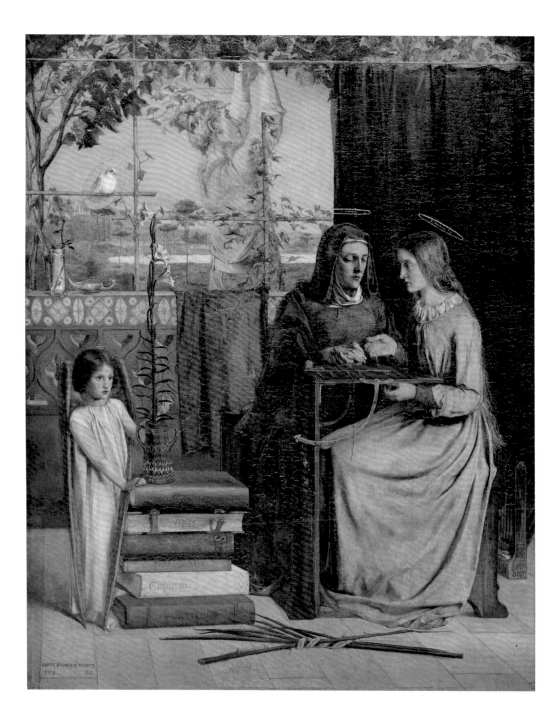

29

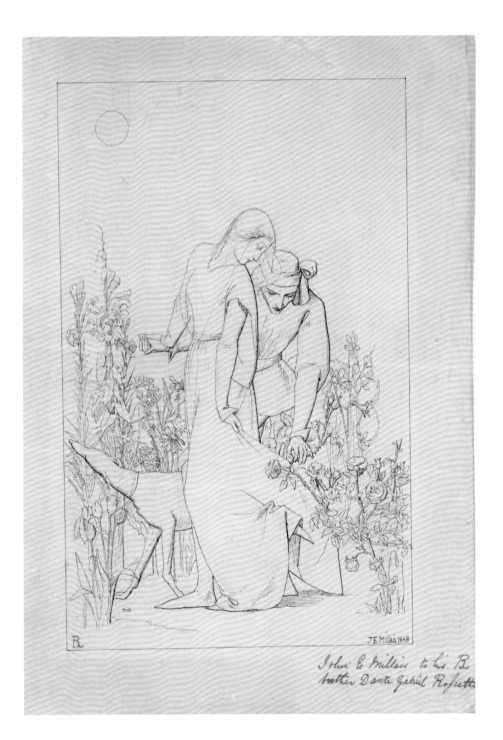

28
John Everett Millais
'My Beautiful Lady' (Lovers by a Rosebush) 1848
Pen and black ink over traces of pencil
25.4 × 16.5
Birmingham Museums and Art Gallery

29
William Holman Hunt
Rienzi Vowing to Obtain Justice for the Death of his Young Brother, Slain in a Skirmish between the Colonna and Orsini Factions 1848–9
Oil on canvas

86.4 × 121.9
Private Collection

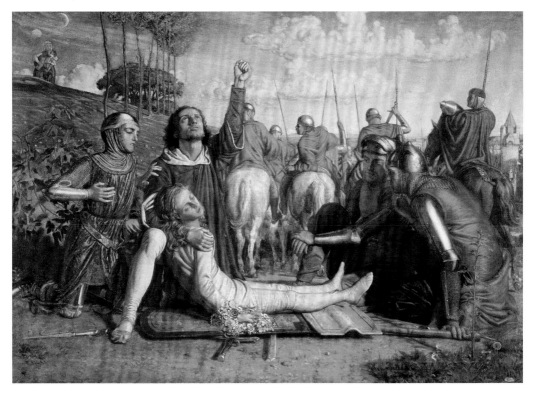

30
John Everett Millais
Isabella 1848–9
Oil on canvas
103 × 142.8
Walker Art Gallery,
Liverpool

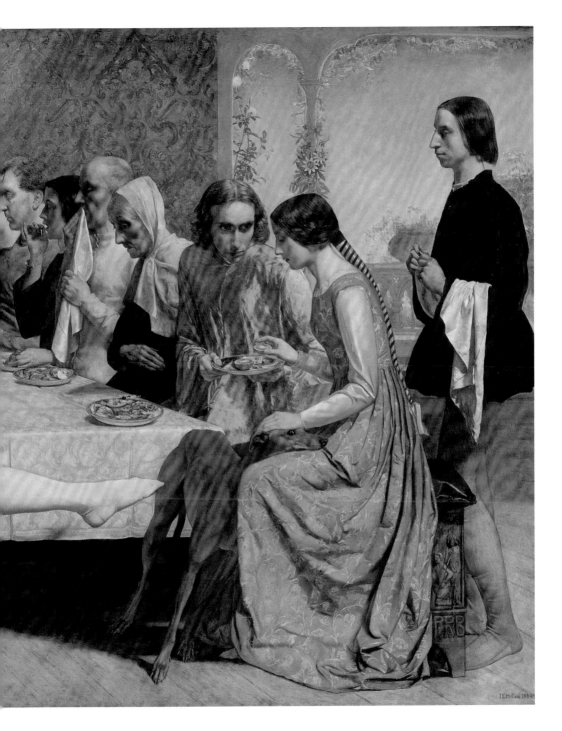

31
John Everett Millais
Christ in the House of His Parents or *The Carpenter's Shop* 1849–50
Oil on canvas
86.4 × 139.7
Tate

32
John Everett Millais
Mariana 1851
Oil on wood
59.7 × 49.5
Tate

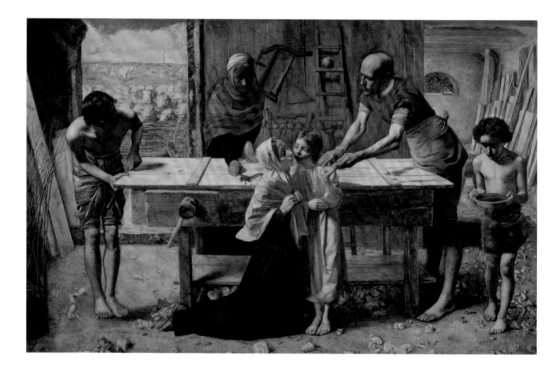

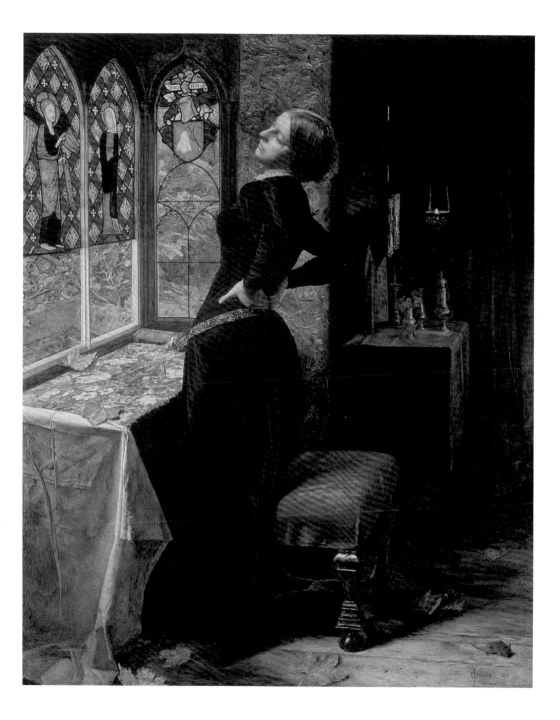

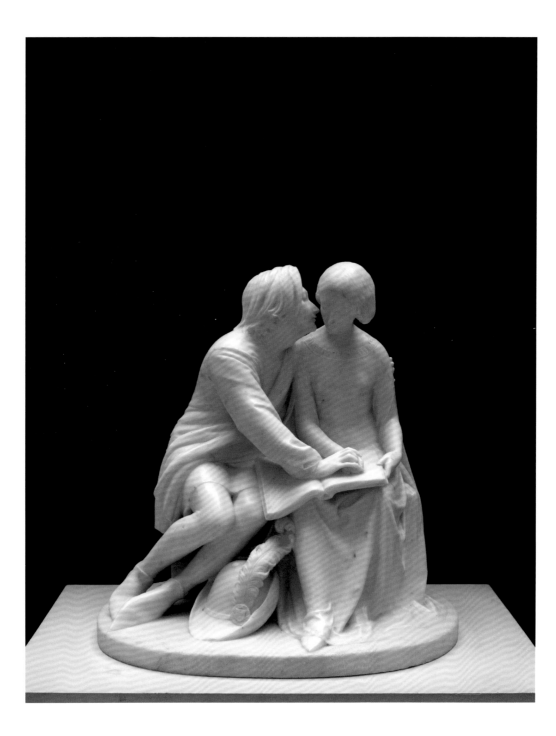

33
Alexander Munro
Paolo e Francesca 1851–2
Marble
67.5 × 66 × 53
Birmingham Museums
and Art Gallery

34
Dante Gabriel Rossetti
The First Anniversary of the
Death of Beatrice 1853–4
Watercolour
42 × 61
Ashmolean Museum,
Oxford

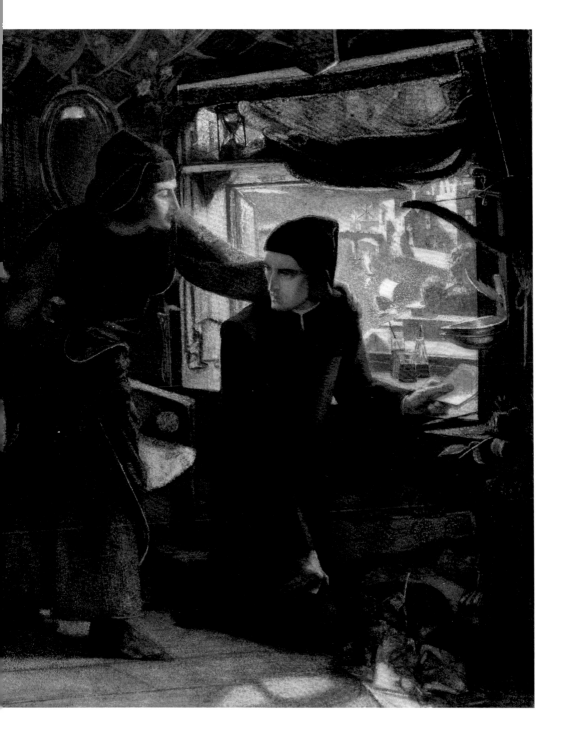

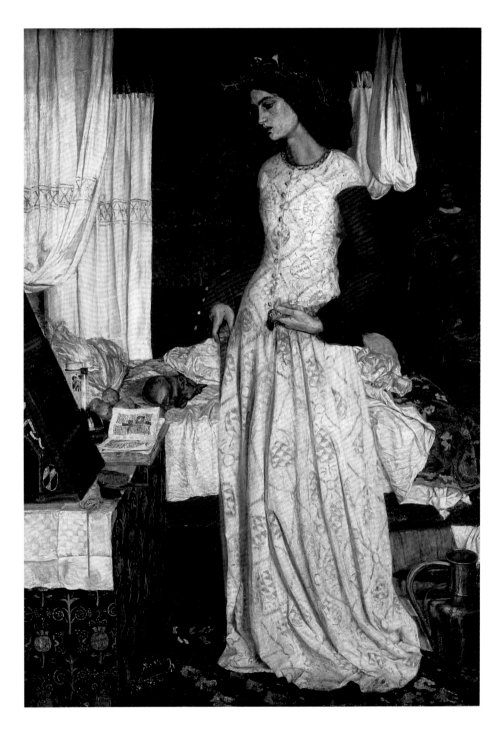

35
William Morris
La Belle Iseult 1858.
Oil on canvas
71.8 × 50.2
Tate

36
Dante Gabriel Rossetti
Dantis Amor 1860
Oil on mahogany
74.9 × 81.3
Tate

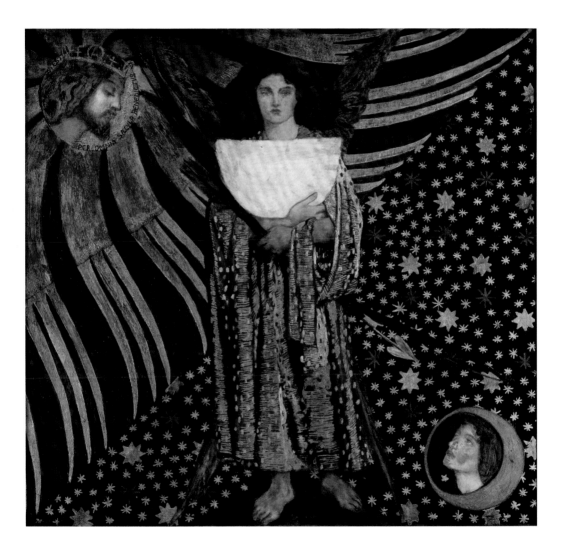

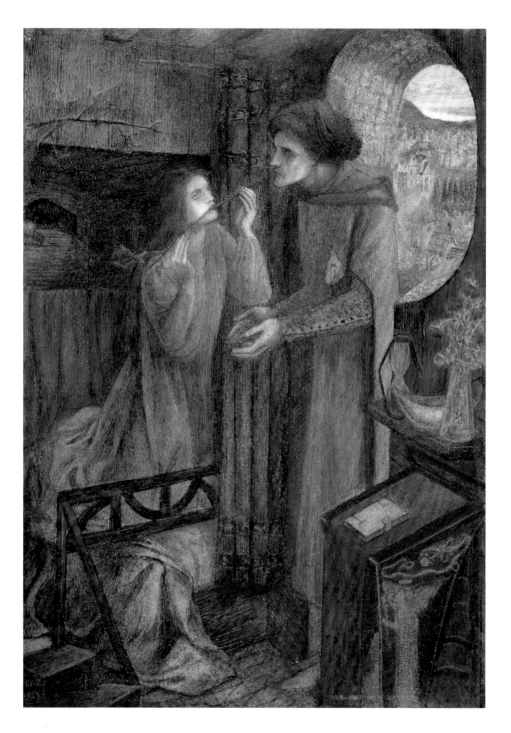

37
Elizabeth Siddall
Clerk Saunders 1857
Watercolour
28.4 × 18.1
Fitzwilliam Museum,
Cambridge

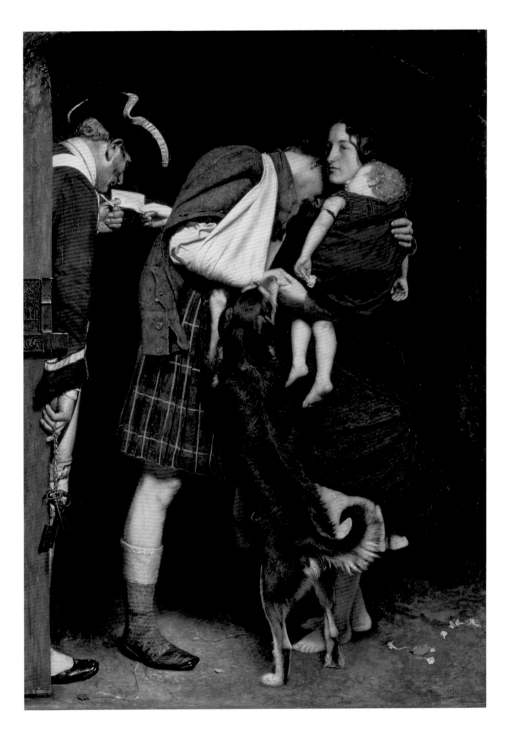

38
John Everett Millais
The Order of Release, 1746
1852–3
Oil on canvas
102.9 × 73.7
Tate

39
Henry Wallis
Chatterton 1856
Oil on canvas
62.2 × 93.3
Tate

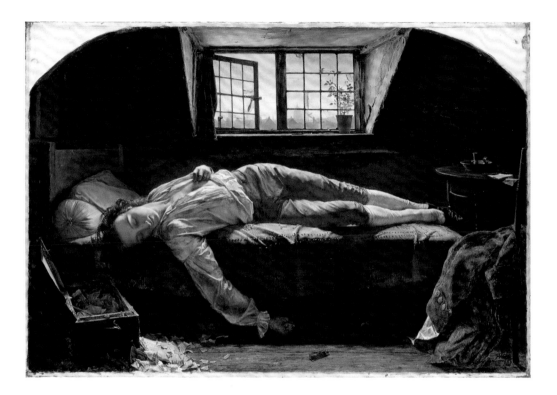

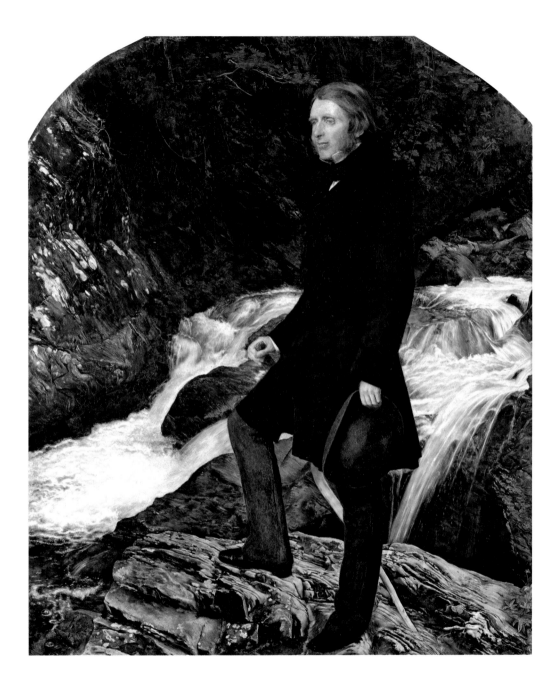

40
John Everett Millais
John Ruskin 1853–4
Oil on canvas
78.7 × 68
Private Collection

41
John Everett Millais
Ophelia 1851–2
Oil on canvas
76.2 × 111.8
Tate

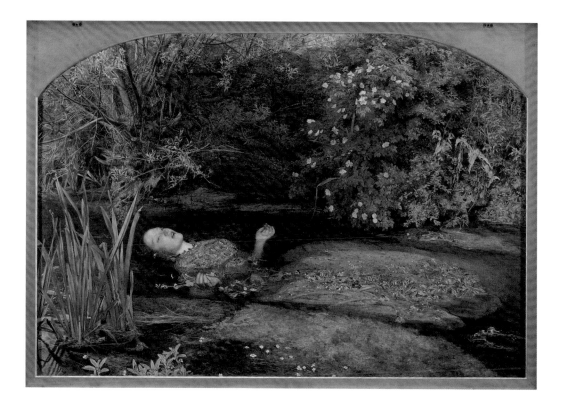

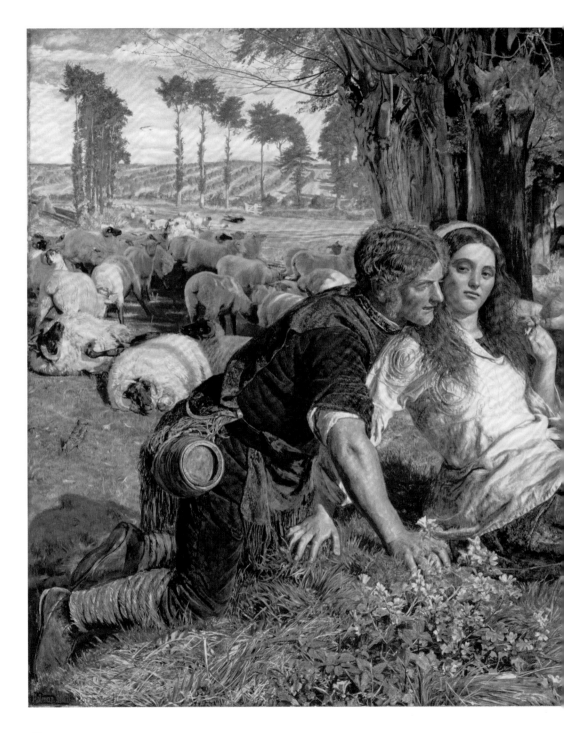

42
William Holman Hunt
The Hireling Shepherd
1851–2
Oil on canvas
76.4 × 109.5
Manchester City Galleries

43
Ford Madox Brown
An English Autumn
Afternoon, Hampstead –
Scenery in 1853 1852–4,
retouched 1856, 1861
Oil on canvas
71.2 × 134.6

Birmingham Museums
and Art Gallery

44
John Brett
Val d'Aosta 1858
Oil on canvas
87.6 × 68
Collection: Lord Lloyd
Webber

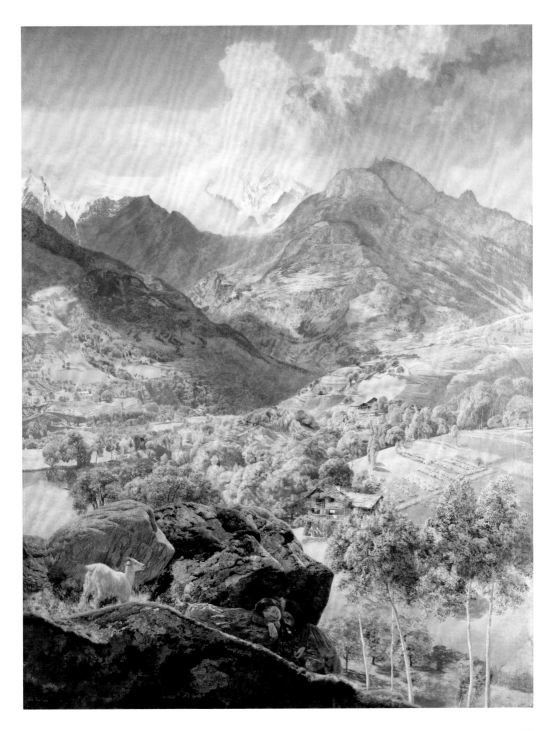

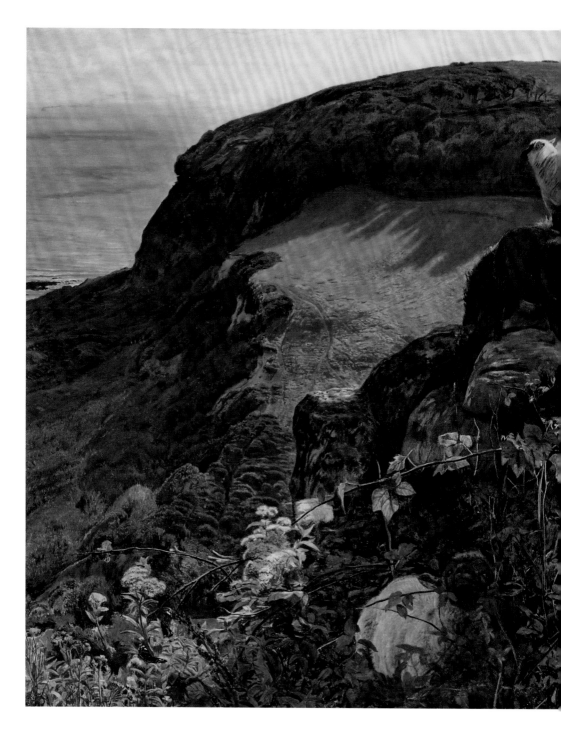

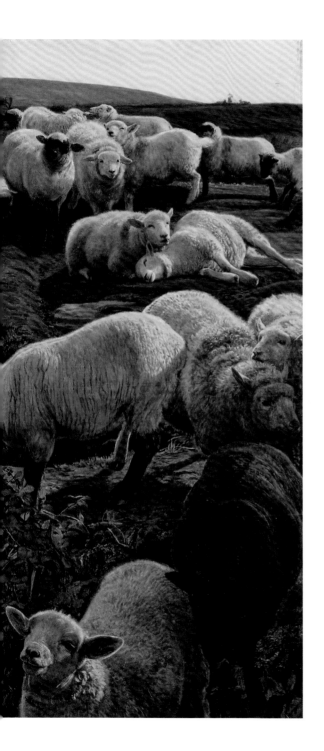

45
William Holman Hunt
*Our English Coasts, 1852
(Strayed Sheep)* 1852
Oil on canvas
43.2 × 58.4
Tate

46
William Dyce
Pegwell Bay, Kent – a
Recollection of October
5th, 1858 1858–60
Oil on canvas
63.5 × 88.9
Tate

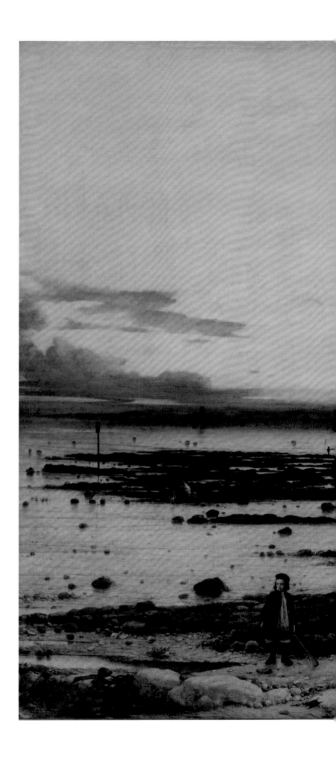

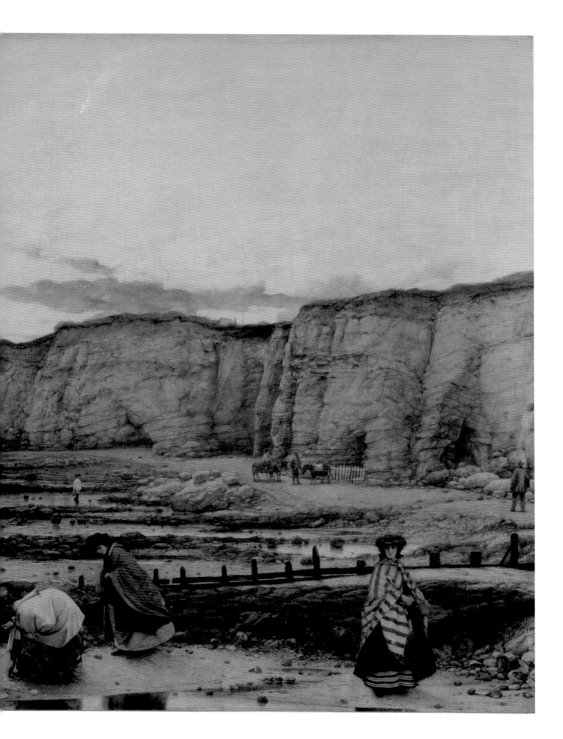

LINNAEUS

47
John Lucas Tupper
Linnaeus c.1856
Limestone
Oxford University Museum
of Natural History

48
Ford Madox Brown
Work 1852–63
Oil on canvas
137 × 197.3
Manchester City Galleries

49
Ford Madox Brown
The Last of England 1852–5
Oil on panel
82.5 × 75
Birmingham Museums
and Art Gallery

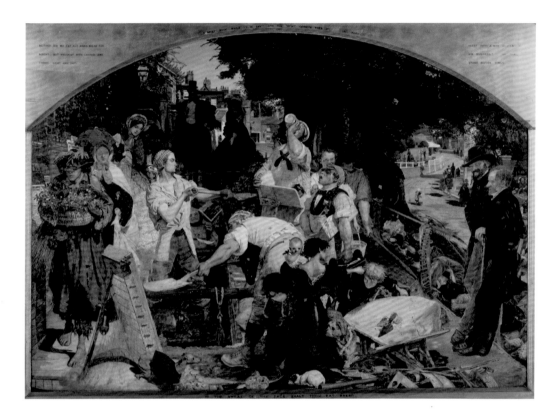

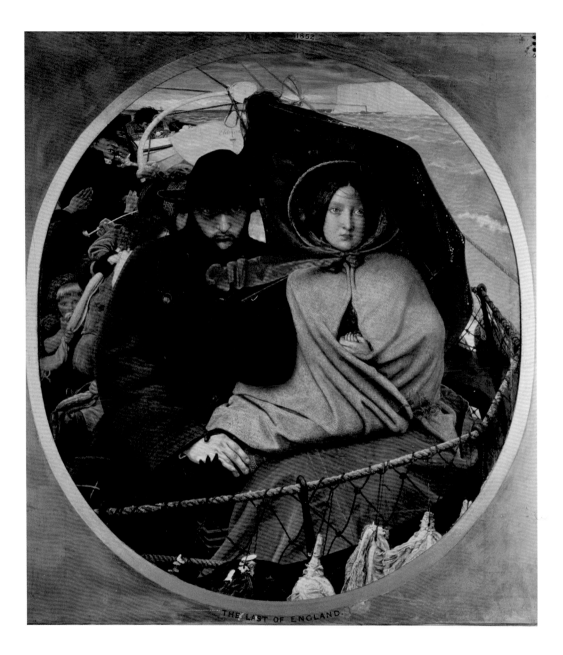

THE LAST OF ENGLAND.

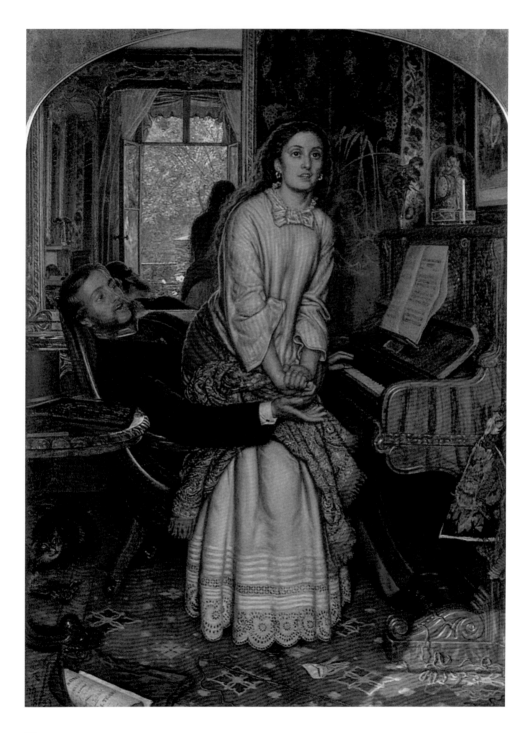

50
William Holman Hunt
The Awakening Conscience
1853–4
Oil on canvas
76.2 × 55.9
Tate

51
Dante Gabriel Rossetti
Found begun 1859
Oil on canvas
88.9 × 76.2
Delaware Art Museum

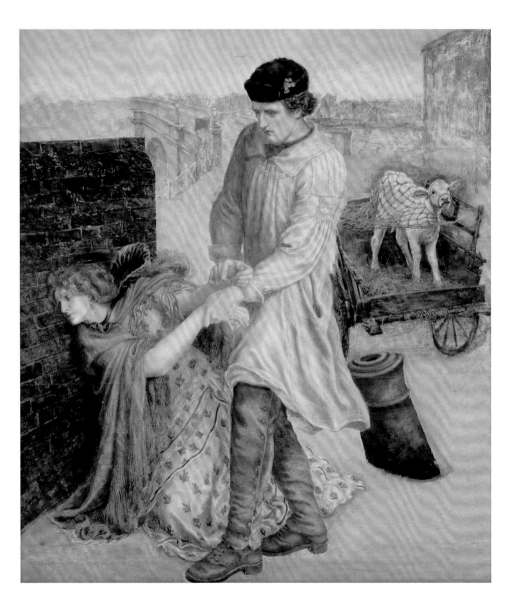

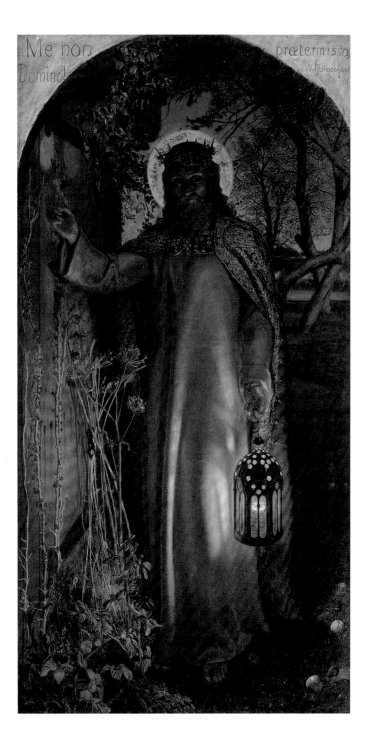

52
William Holman Hunt
The Light of the World 1851–3,
retouched 1858, 1886
Oil and gold leaf on canvas
122 × 60.5
Keble College, Oxford

53
William Holman Hunt
The Scapegoat 1854–5
Oil on canvas
87 × 139.8
Lady Lever Art Gallery,
National Museums of
Liverpool

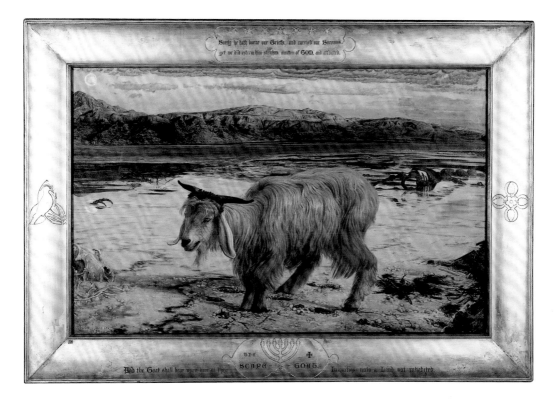

54
William Holman Hunt
The Finding of the Saviour in the Temple 1854–60
Oil on canvas
85.7 × 141
Birmingham Museums and Art Gallery

55
John Everett Millais
Autumn Leaves 1855–6
Oil on canvas
104.1 × 73.7
Manchester City Galleries

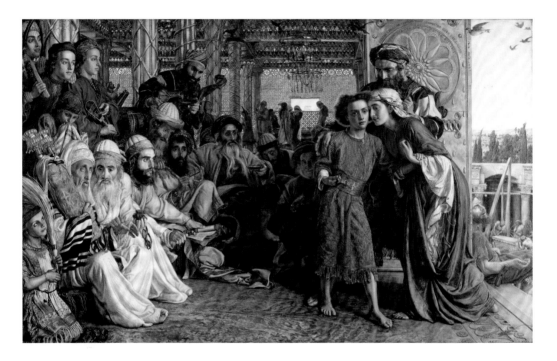

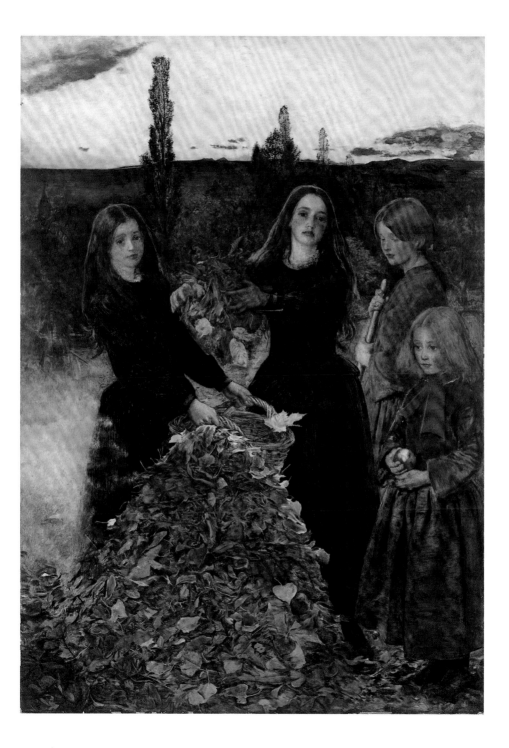

56
John Everett Millais
Sophie Gray 1857
Oil on paper laid on wood
30 × 23
Private Collection courtesy
of The Leicester Galleries,
London

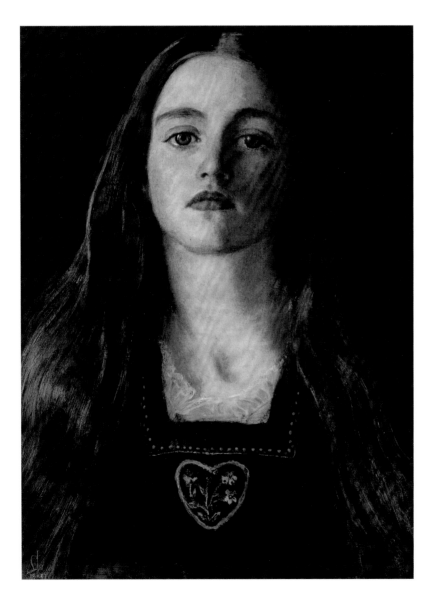

57
Dante Gabriel Rossetti
Bocca Baciata 1859
Oil on panel
32.1 × 27
Museum of Fine Arts,
Boston

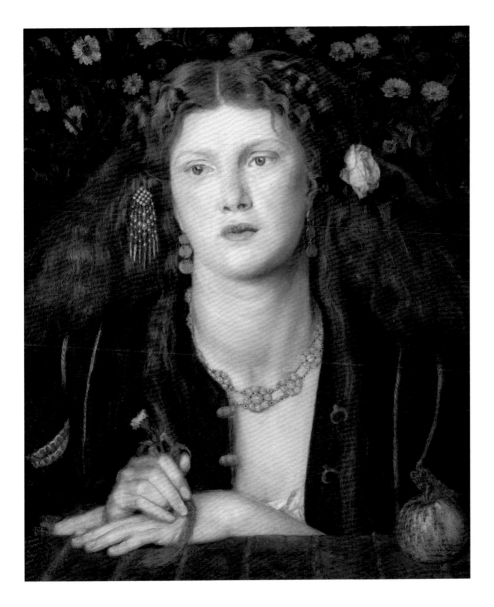

58
Dante Gabriel Rossetti
Beata Beatrix c.1864–70
Oil on canvas
86.4 × 66
Tate

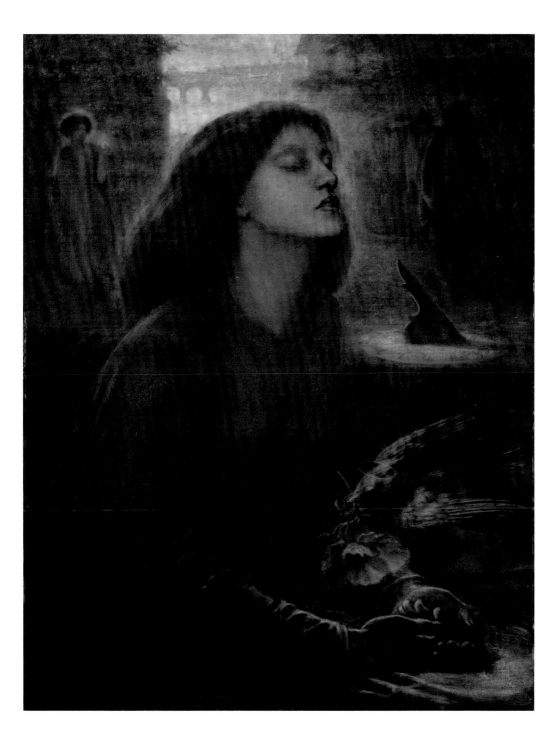

59
Edward Burne-Jones,
William Morris and
John Dearle
*The Attainment: The
Vision of the Holy Grail to
Sir Galahad, Sir Bors and
Sir Perceval* 1890–94

Cotton, wool and silk
239 × 749
Private Collection

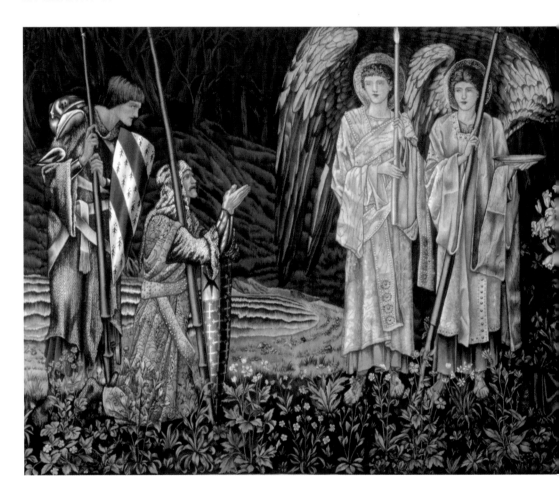

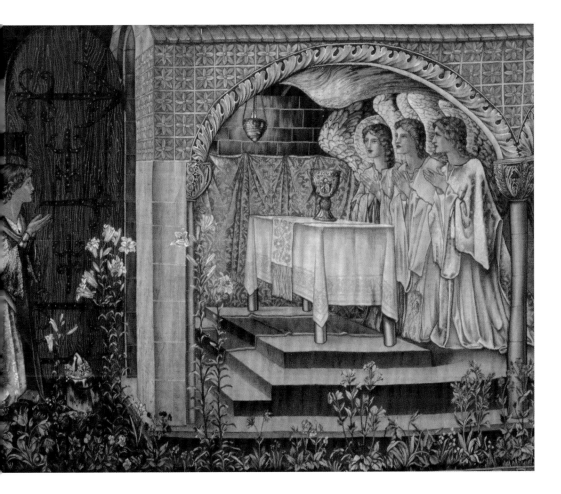

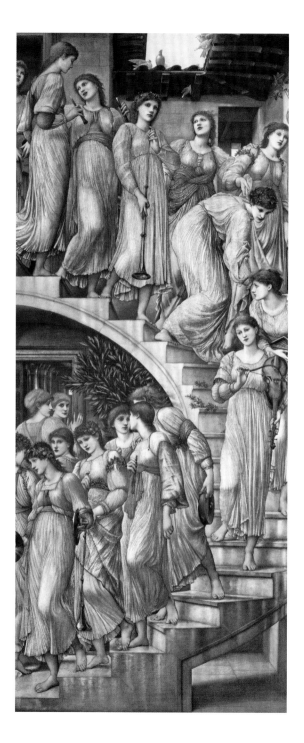

60
Edward Burne-Jones
The Golden Stairs 1880
Oil on canvas
269.2 × 116.8
Tate

61
Edward Burne-Jones
Laus Veneris 1873–8
Oil on canvas
119.4 × 180.3
Laing Art Gallery,
Newcastle-upon-Tyne

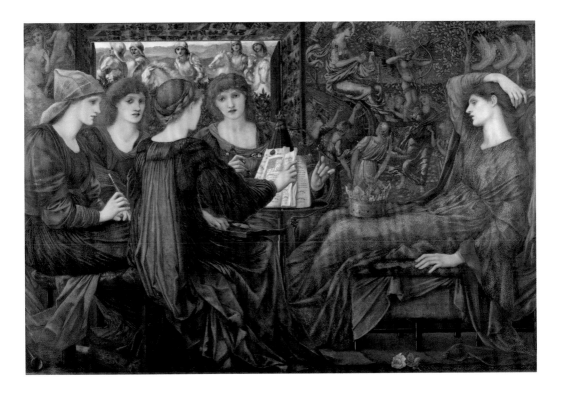

62
Edward Burne-Jones
The Doom Fulfilled 1888
Oil on canvas
155 × 140.5
Staatsgalerie Stuttgart,
Germany

63
Dante Gabriel Rossetti
Astarte Syriaca 1877
Oil on canvas
185 × 109
Manchester City Galleries

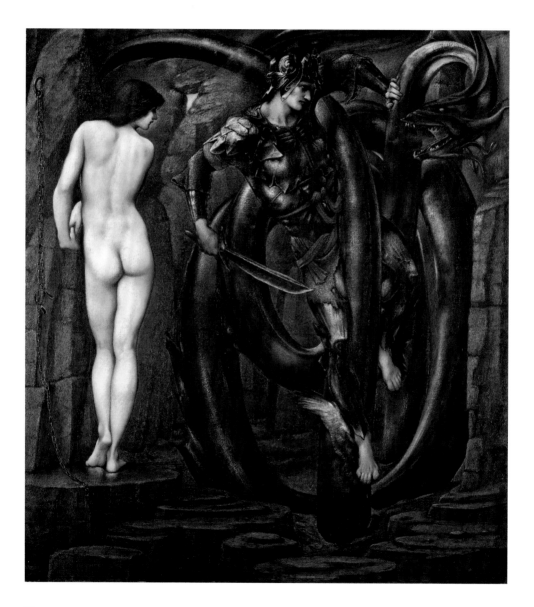

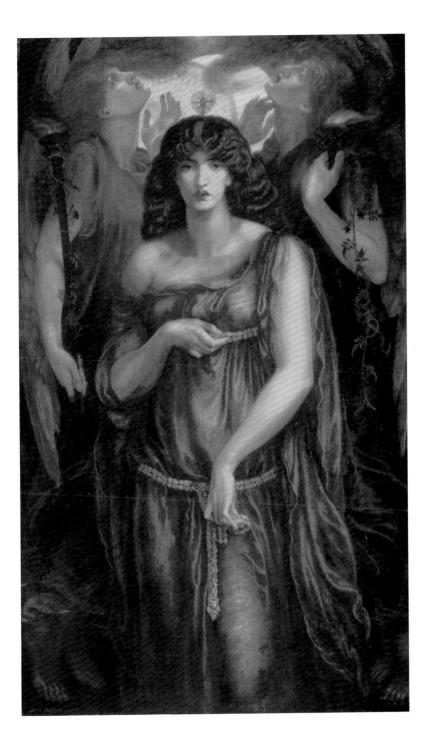

64
William Holman Hunt
with the assistance of
Edward Robert Hughes
The Lady of Shalott
c.1888–1905
Oil on canvas
188 × 146.1
Wadsworth Atheneum,
Hartford, CT

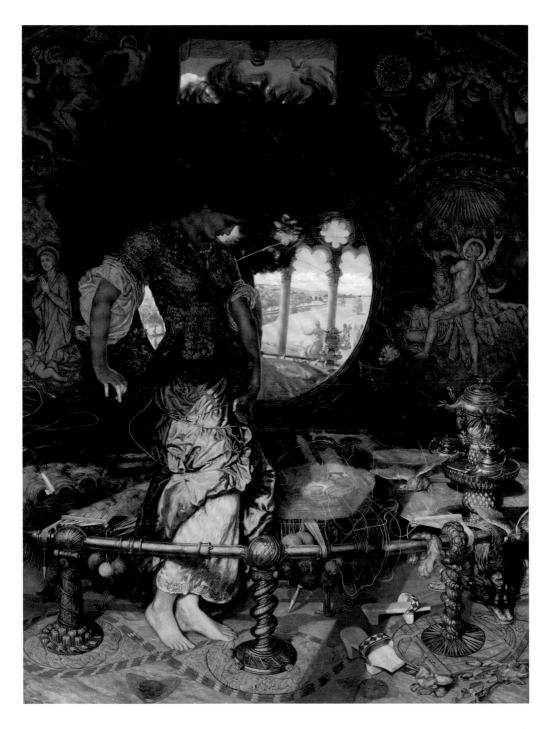

Notes

1 William Holman Hunt, *Pre-Raphaelitism and the Pre-Raphaelite Brotherhood*, London and New York 1905, vol.1, p.178.

2 Charles Dickens, 'Old Lamps for New Ones', *Household Words* 12 (15 June 1850), p.265.

3 John Ruskin, 'The Pre-Raffaellites [sic] ', *Times* (letter), 13 May 1851, p.8.

4 From *Modern Painters*, vol.1, 1843, quoted in Tim Barringer, *Reading the Pre-Raphaelites*, New Haven and London 1998, p.60.

5 Quoted in Leslie Parris (ed.), *The Pre-Raphaelites*, exh. cat., Tate Gallery, London 1984, p.111.

6 Quoted in Parris 1984, p.175.

7 Quoted in Barringer 1998, p.76.

8 This print was a clever play not only on Millais's *A Dream of the Past* (1857; Lady Lever Art Gallery) but also on the medieval aspirations of the brotherhood as well as D.G. Rossetti's verse. See Mary Bennett, *Artists of the Pre-Raphaelite Circle: The First Generation*, London 1988, pp.131–7. Dated 4 May 1857, it purportedly appeared five days after the Royal Academy opened with Millais's work on display, and three hundred prints were sold in the first week. See E.R. and J. Pennell, *The Whistler Journal*, Philadelphia, PA 1921, p.22.

Tim Barringer, *Reading the Pre-Raphaelites: Revised Edition*, New Haven and London 2012.

Mary Bennett, *Ford Madox Brown: A Catalogue Raisonné*, 2 vols., New Haven and London 2010.

Judith Bronkhurst, *William Holman Hunt: A Catalogue Raisonné*, 2 vols., New Haven and London 2006.

Leslie Parris (ed.), *The Pre-Raphaelites*. exh. cat., Tate Gallery, London 1984.

Linda Parry (ed.), *William Morris*, exh. cat., Victoria and Albert Museum, London 1996.

Elizabeth Prettejohn, *The Art of the Pre-Raphaelites*, London and Princeton 2000.

Elizabeth Prettejohn, *Rossetti and his Circle*, London 1997.

Jason Rosenfeld, *John Everett Millais*, London 2012.

Jason Rosenfeld and Alison Smith, *Millais*, London 2007.

Joyce H. Townsend, Jacqueline Ridge and Stephen Hackney (eds.), *Pre-Raphaelite Painting Techniques*, London 2004.

Julian Treuherz, Elizabeth Prettejohn and Edwin Becker, *Dante Gabriel Rossetti*, exh. cat., Zwolle, Amsterdam and Liverpool 2003.

Julian Treuherz, *Ford Madox Brown: Pre-Raphaelite Pioneer*, exh. cat., Manchester Art Gallery 2011.

Diane Waggoner (ed.), *The Pre-Raphaelite Lens: British Photography and Painting, 1848–1875*, exh. cat., National Gallery of Art, Washington D.C. 2010.

Index

First published 2012 by order of the Tate Trustees
by Tate Publishing, a division of Tate Enterprises
Ltd, Millbank, London SW1P 4RG
www.tate.org.uk/publishing

A catalogue record for this book is available from
the British Library

ISBN 978 1 84976 024 9

Distributed in the United States and Canada by
ABRAMS, New York

Library of Congress Control Number applied for

Designed by Anne Odling-Smee, O-SB Design
Colour reproduction by DL Imaging Ltd, London
Printed in and bound in China by C&C Offset
Printing Co., Ltd

Front cover: John Everett Millais,
Mariana 1851 (detail of fig.32)
Frontispiece: Dante Gabriel Rossetti,
Bocca Baciata 1859 (detail of fig.57)

Measurements of artworks are given in
centimetres, height before width.

MIX
Paper from
responsible sources
FSC® C008047
www.fsc.org

Photo credits

All images are copyright the
owner of the work unless
otherwise stated below

Ann S Dean, Brighton / Bridgeman
 Art Library fig.12
© Bradford Museums and Galleries,
 West Yorkshire, UK / Bridgeman
 Art Library fig.26
Bridgeman Art Library figs.20, 29
© Country Life Picture Library
 figs.22, 23
Delaware Art Museum,
 Wilmington, USA / Bridgeman
 Art Library fig.51
Fitzwilliam Museum, University of
 Cambridge, UK / Bridgeman Art
 Library fig.6, 37
Photo © The Mass Gallery /
 Bridgeman Art Library fig.14
Photo © Peter Nahum at The
 Leicester Galleries, London /
 Bridgeman Art Library fig.56
National Gallery of Art, Washington,
 D.C, Harris Whittemore
 Collection fig.16
Oxford University Museum of
 Natural History, UK / Bridgeman
 Art Library fig.47
The Royal Collection © 2012 Her
 Majesty Queen Elizabeh II / The
 Bridgeman Art Library fig.17
© Sotheby's / akg-images fig.59
© Tyne & Wear Archives &
 Museums/ Bridgeman Art Library
 fig.61
By permission of the Warden,
 Fellows and Scholars of
 Keble College, Oxford / Tate
 Photography / David Lambert and
 Rod Tidnam fig.52
Wadsworth Atheneum / Art
 Resource, NY / Scala, Florence
 fig.64